PORTRAITS

Created by Claude Delafosse
and Gallimard Jeunesse
Illustrated by Tony Ross

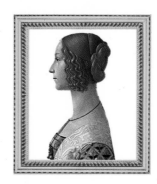

A FIRST DISCOVERY **ART** BOOK

Cartwheel
·B·O·O·K·S·®

SCHOLASTIC INC.
New York Toronto London Auckland Sydney

D1064011

A portrait is the image of a person made by an artist. This portrait of a king, made of stained glass, forms the window of a church.

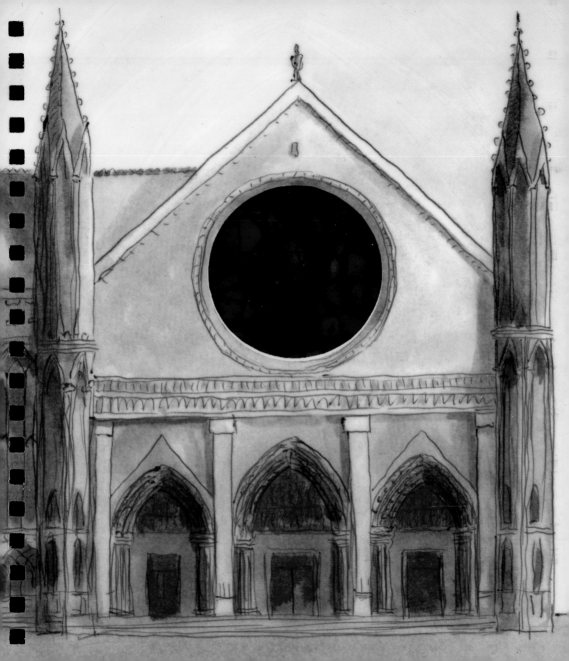

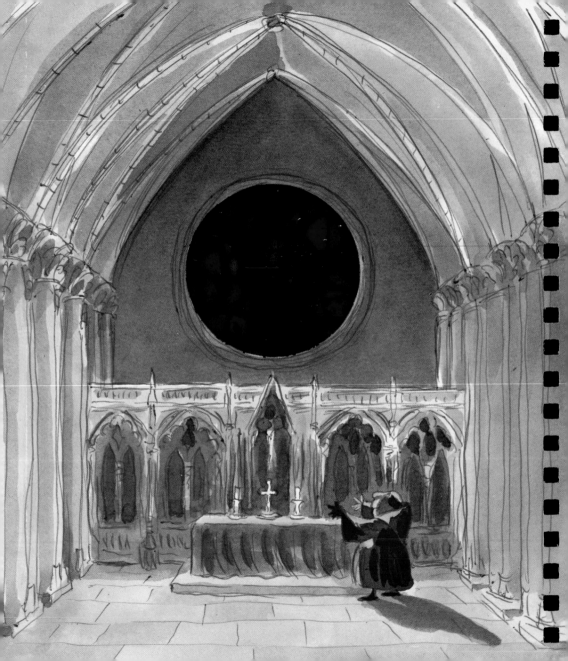

Shine a flashlight behind the window—
and you'll see the colors reflected
in the church.

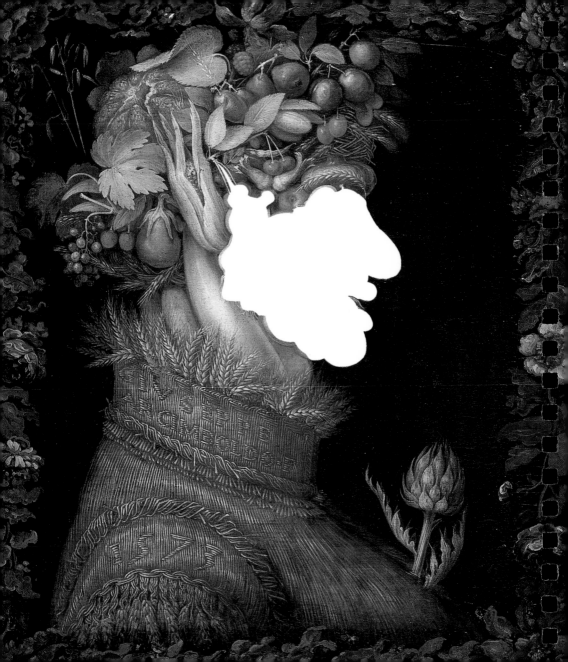

Most artists wouldn't use fruits and vegetables to make a portrait...

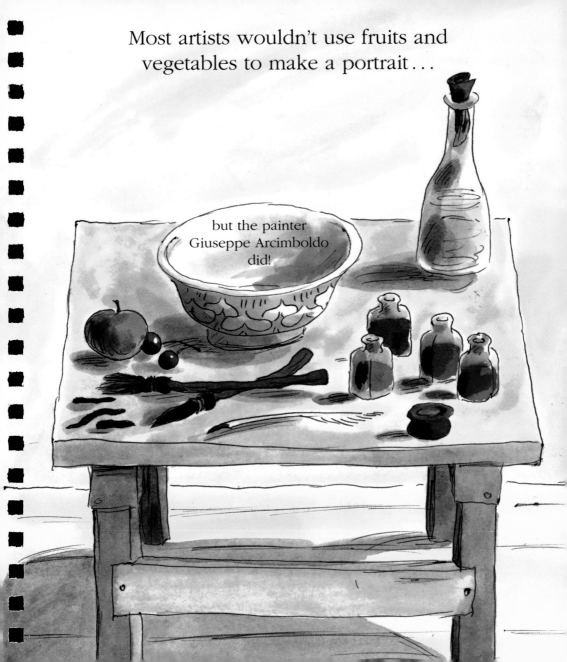

but the painter Giuseppe Arcimboldo did!

Rembrandt etched his own portrait onto
the other side of this copper plate.

Lift the plate
to see the picture.

The print of the portrait onto paper is called an engraving.

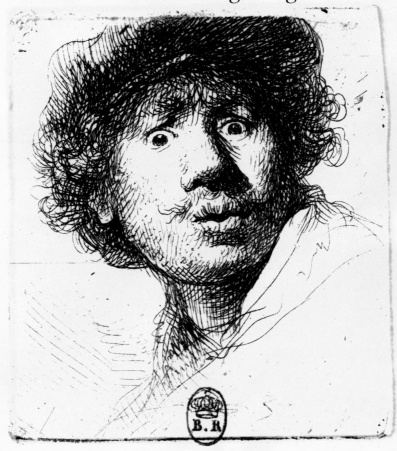

Self-portrait of Rembrandt

A
portrait
can also be
made from clay or
stone.

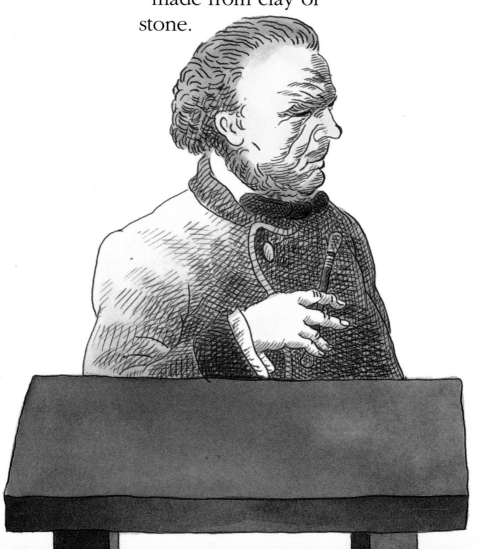

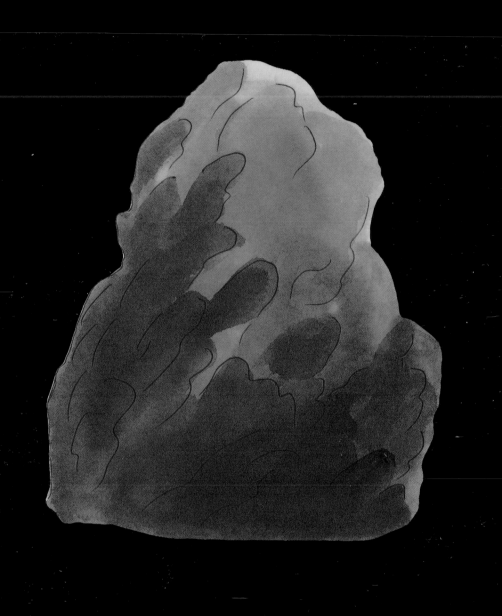

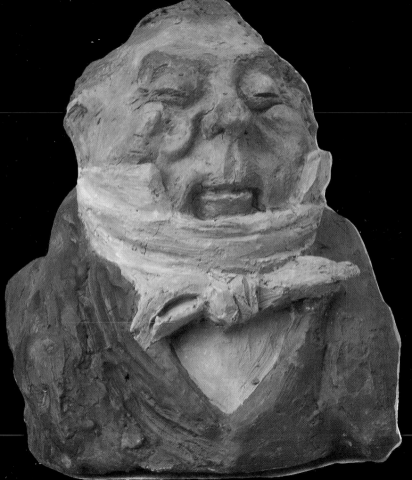

Let's see
what the
artist
Honoré
Daumier
sculpted.

He made this funny
sculpture of a politician
in 1831.

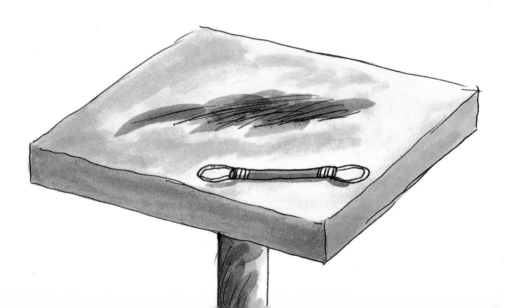

What is this strange
scene by Salvador Dali?

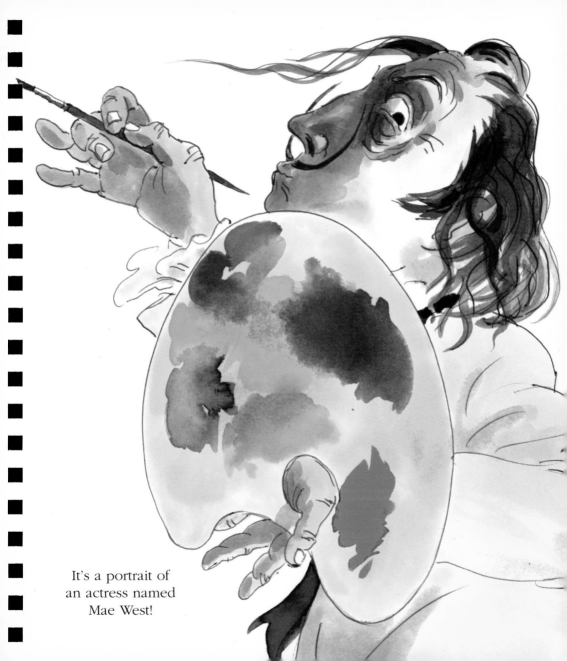

It's a portrait of an actress named Mae West!

Why is this old
broom in a book
about art?

It's also a portrait—
by Gaston Chaissac.

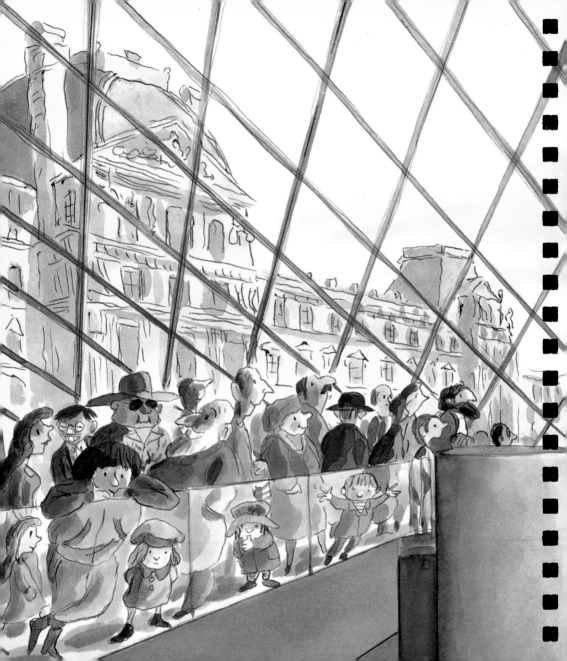

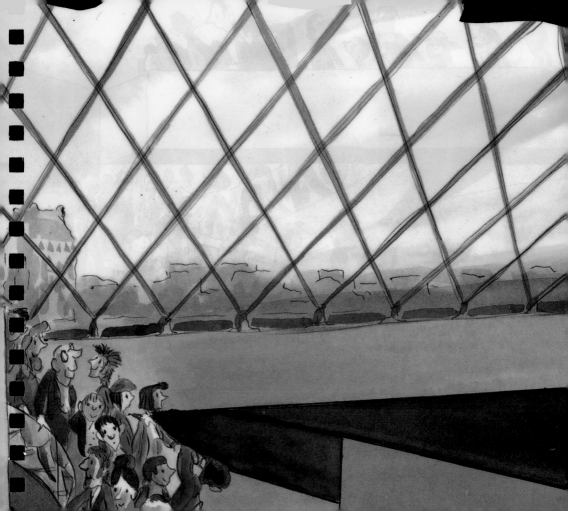

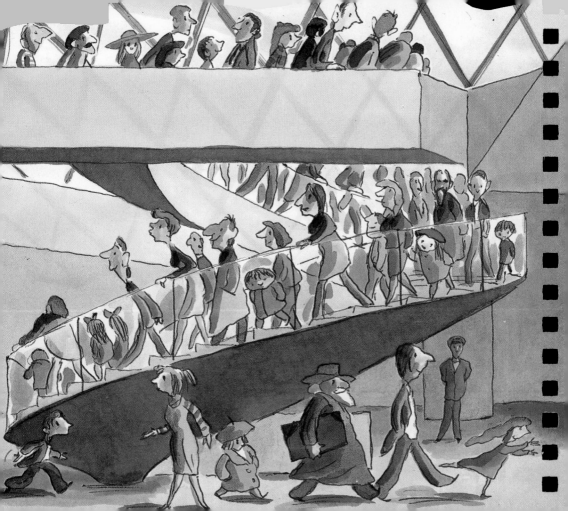

Why do thousands of people visit the Louvre Museum in Paris each year?

To see the famous smile of *The Mona Lisa.*

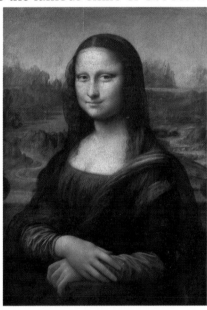

◦ Leonardo da Vinci ◦

Let's visit this gallery of famous portraits . . .

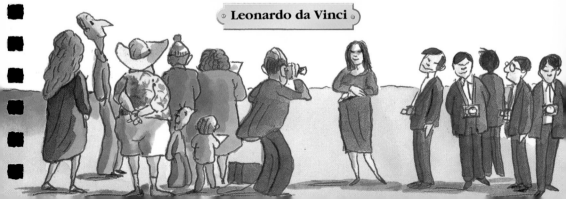

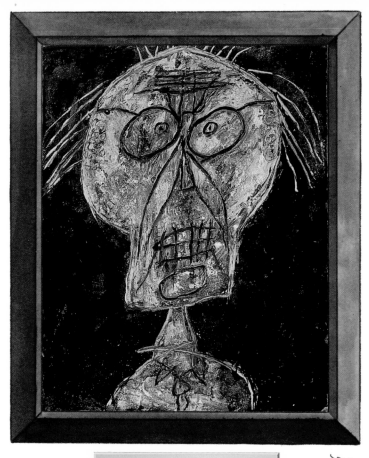

Dhôtel shaded with apricot
Jean Dubuffet

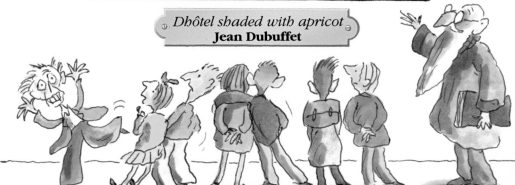

Do you see anything funny about some of the visitors in the gallery?

The Childhood of Ubu
Joan Miró

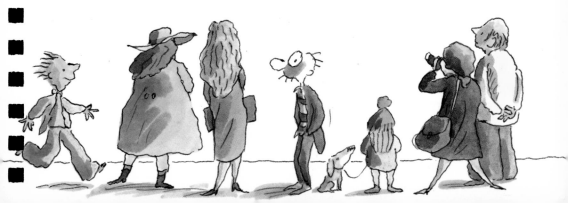

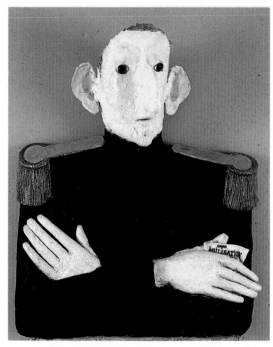

L'ira l'ira pas
Jean-Jules Chasse-Pot

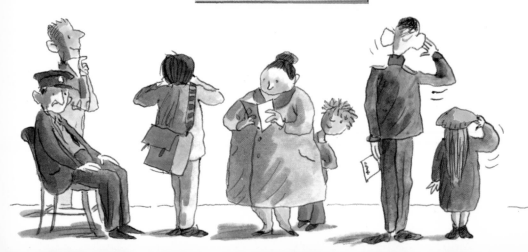

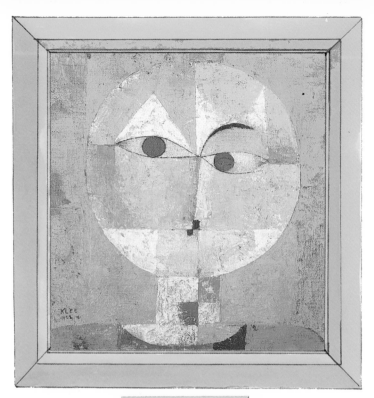

Senecio
Paul Klee

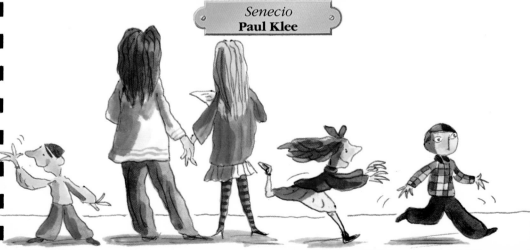

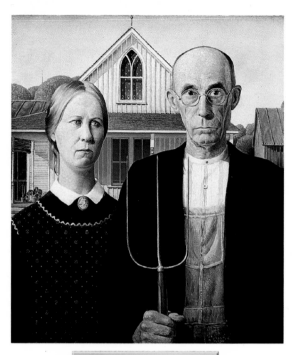

American Gothic
Grant Wood

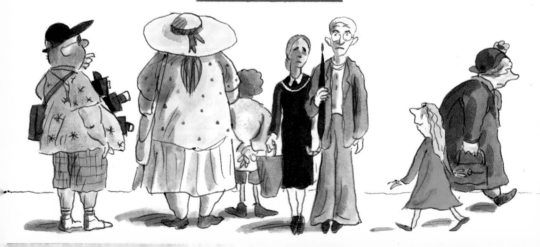

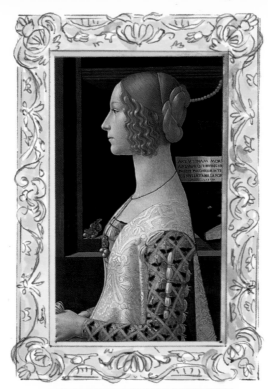

Giovanna Tornabuoni
Ghirlandaio

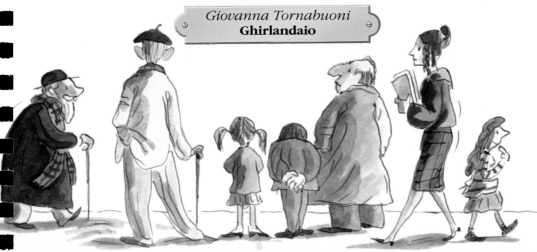

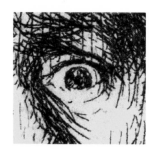

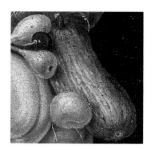

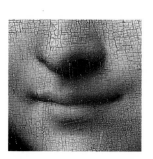

Look closely at these details from
the portraits you have seen in this book.
Can you figure out which works of art
they belong to?

Now, why not make a
portrait of someone you know—
or a self-portrait?

Table of Illustrations

Other titles in the *First Discovery Art* series:
Landscapes
Paintings
Animals

Library of Congress Cataloging-in-Publication Data available.
Originally published in France under the title *Les Portraits* by Editions Gallimard.

ISBN 0-590-55200-7

Copyright © 1993 by Editions Gallimard. This edition English translation by Jennifer Riggs.
This edition Expert Reader: Alice Schwarz, Museum Educator.
All rights reserved. Published by Scholastic Inc., 555 Broadway, New York, NY 10012 by arrangement with Editions Gallimard•Jeunesse, 5 rue Sebastien-Bottin, F-75007, Paris, France.

CARTWHEEL BOOKS and the CARTWHEEL BOOKS logo are registered trademarks of Scholastic Inc.

12 11 10 9 8 7 6 5 4 3 2 1 5 6 7 8 9/9 0/0

Printed in Italy by Editoriale Libraria
First Scholastic printing, October 1995